# Modest Gifts

TO NORRIS

# Modest Gifts

POEMS AND DRAWINGS

Norman Mailer

RANDOM HOUSE TRADE PAPERBACKS    NEW YORK

I don't know
where to
start

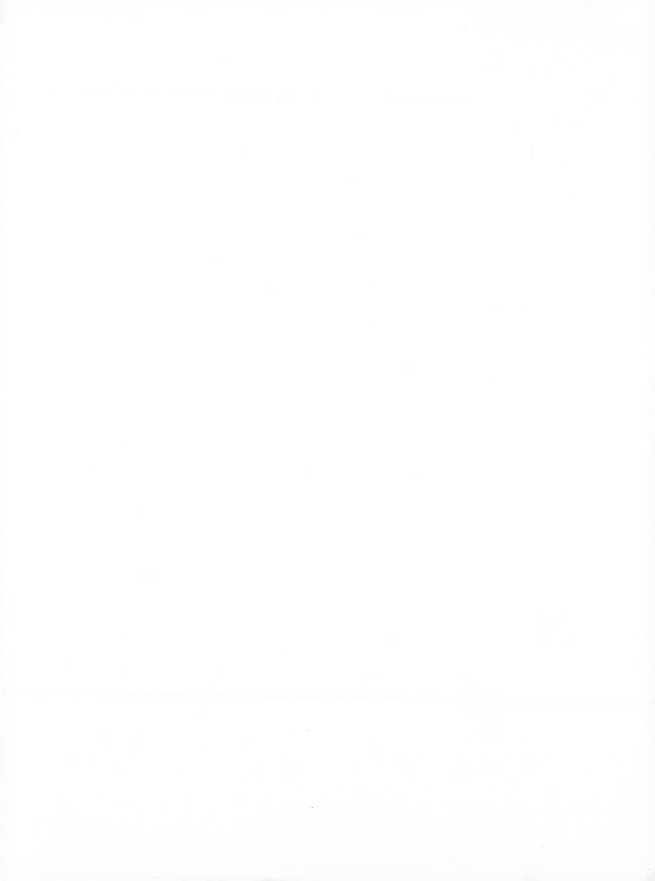

Well, in fact I do know. It is to warn the buyer. For the title is accurate—the gifts you will purchase are modest. William Merrill once wrote that a poem which was too easy to read was without value. "Difficult surfaces [can work] through to the poem's emotional core."

These pieces, for the most part, will be comprehensible on first approach. Some barely qualify as poems. They are snippets of prose called short hairs, there to shift your mood a hair's width. Perhaps one element of a good poem is its power to succeed in altering a reader's mood, but I will make no such claim for most of these inclusions, and something of the same can be said of the drawings. Is one to call them caricatures, cartoons, squibbles, or doodles? At best, they are line drawings—shading is beyond my means. If I now combine these line drawings with the short hairs, it is to offer the reader an easy pleasure. My serious work, such as it is, does not always accomplish this. Nor does it always want to. I belong to that dwindling group of novelists who wish to make a demand on their audience. I want the reader to owe a little more to the work than some passing gratitude for the mild enlivening of his or her leisure time. My mind was shaped at an early age, after all, by the great Russian novelists with their implicit expectation that you, the reader, are there to suffer with the writer. Why? For a huge reason—to partake of the ongoing quest to deepen our comprehension of life and eternity, as if—for fact!—life and eternity cannot survive without such a quest.

I still believe this. But by the age of eighty, tolerance insists on seeping into dedication. Casual pleasures become more meaningful even as lively pleasures sleep, and a

few pains turn chronic. So, amusement becomes more of a virtue in itself. I now like to think that a limited ability to draw when coupled with a merry pretension to write poetry can turn sometimes into more than the sum of its parts, even as a minus times a minus will produce a plus. In mathematics, that always operates. In art, it can happen now and again. Obviously, I hope this is such an occasion.

I am not, however, being altogether candid. There are a few good poems and a few good drawings here. Which ones they may be, I keep to myself. My real pleasure will come if twenty different candidates are nominated by a score of men and women.

Here, I must offer a further confession. I knew this unashamedly self-serving attitude would have to disclose itself—modesty (at least for me) is too harsh a stricture to maintain all the way through two pages of a preface.

One more note:

A few poems were revised for this edition, but most were written in the early Sixties and published in a book called *Deaths for the Ladies (and other disasters)*. The rest appeared by 1965 in *Cannibals and Christians*. Most of the drawings were done, however, in recent years. Nonetheless, the sketches are not all that removed from the tone of the short hairs, even if my ongoing mood in those years when the poems were written was considerably more intense. So I think it's appropriate to include an appendix in this book. It is the introduction I wrote for a mass-market paperback edition of *Deaths for the Ladies,* which came out almost ten years after the first publication in 1962, and it will offer a subtext to those readers who find themselves somewhat intrigued by what follows.

# I

# Cocktail Party

## A. Voices

Don't speak to me
until I've had a drink.

I never dreamed that I would be the one to sell our family home.

My mother tells me
that I would be a
beauty if I would
just pull myself
together.

options.com shoot me
an E-mail.

Sometimes I feel
as if I have a
picture of the whole.

Sometimes I feel
as if I have no grasp
of it at all.

I
was
hysterical
stated
the girl

       I
dropped
my
  god
damned con
tact lens
  down
  the drain

Then
this
creep
called at four
    A.M.

                    Hel
                      lo Kook
                      he said

                    Guess what:

                    I just
                    found
                    your
                    contact
                    lens.

I feel
as if
I'm beginning
to look like
my cell phone.

My new
date
is fantastic.
Don't try
to steal him.

Don't try to tell me, Randy, that Pablo P. didn't know what it was all about.

I don't really believe
that I am gay. It's just...

How can you
       say
you're
  only
  three-quarters
        a man,
why you're
       completely
       a man
       said the
          lady
          in a
          three-quarter voice.

I still
love
him
deeply
   she said
   deeply
   out of her
   double
   chin.

I must say I am
not happy being
a divorced man.

I've made money
all my life. So,
why do I feel
punched-out?

The
    cigarette
    smoker
    said

    I'd
    rather
    waste it
    than give
    it

    away

America should have
two churches
one for people
who smoke
and one for those
who don't

I think
I'll switch
from ginger ale
    now

to a
nice
    glass
    of
    soda.

Drinker
with a
problem said:
I'll drink
to that.

I'm getting
very little
out of this.

I'm getting nothing

Can't you see?
It's time to leave.

# Cocktail Party

## B. Lingerers, Laggards & Blackguards

Why can't
Garry Trudeau
find a spot
for me?

This much
I know.
Speed will
never
betray me.

Just let me kiss
her once and she
will kiss me back
a hundred times

It's not only that
I'm afraid of things that go
bump in the night. It's more
that I just don't trust
the universe.

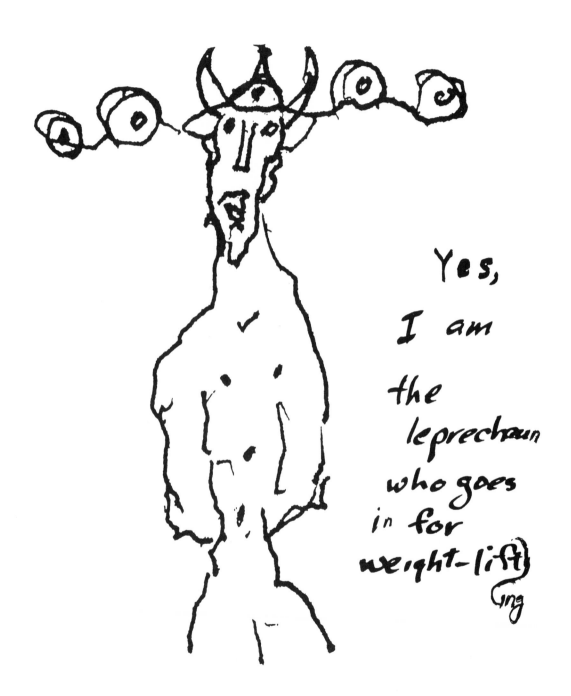

Yes,

I am

the
leprechaun
who goes
in for
weight-lift)
ing

I have reason to believe
that the occult is on
its way back

I don't mind
  a party that
      gets
  a little rough
  but did you
    have to throw
        up
        in my foyer?

Despair never
  said the
  drunk,
I'll pick
      it up
  I'll really
  pick it up
  because I don't
  believe
  in leaving
  my leavings
  at a lady's
      door
  when she's a lady
      like you
      you crappy
      old
      unhappy
      bag of an armpit
        anyone ever
        say
        you're beautiful
        said the drunk as he fell on his nose
        trying to kiss lady and her fortune.

# II

# Maladies of Centralists

She believed
in the
efficacy
of patterns
So she worked
on the
Avenue
of the
Madison
and
sold
glop

The steel
and
glass
of some womb
that
lacked
the love
to
give her eyes

This ill
whose
first
symptom
is
a
monotony
of nights

UNITED CITIZENS PROTEST

Gather
me
a
monotony
of
names

Putting up
  with
    something
  you don't
            like
  and calling
  it charming
    spells
    age-in-the-face,
    dear,
      said
       the
       skin
       graft
      as it
      said
      hello
    and moved into its new home
                        on the neck

THERAPY

People
    who
despise
themselves
    wear
    dingy
    under-
    garments
        said
        the
        psychiatrist
    flinging
the sorrows
    of his
    seed
        out, off, and away
                into a
                white
                linen
                hand-
                kerchief
                with a
                hand-
                rolled
                edge.

Repetition
   kills the
   soul
for its offers
   dull the
   hole
   of memory
where life
      was once
      a tree
      nestling the root
      with gyres
        of sky
      and
        midnight's
        murmuring
        summer.

A plague is
          coming
          named
                    Virus Y S X
          still unsolved
          promises to be
                    proof
                    against
                    antibiotics
                    psychotherapy
                    Internet ventures
                    mega-vitamins
                    ATMs
                    celebrity diets
                    pundits
                    cell phones
                    foundations
                    cruise ships
                    rehab
                    spas
                    Viagra
                    anthrax
                    Botox
                    Prozac
                    breast enhancement
                    liposuction
                    insider trading
                    political correctness
                              and
                              even a good piece
                              of rare

When that unhappy day
          comes to America
          let Islam
          take over.
The best defense is
          infection.

As it grows,
    the flower
    breaks
    through the stone.

It has yet
    to prove
    itself
    against
    the clay.

Gray without grace
    day.

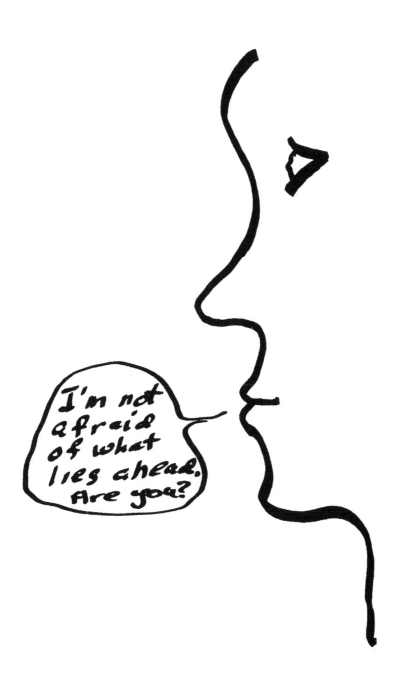

TOGETHERNESS

My flesh must smell like an old tire
my sex is bitter and gone
my days are leafless and all sleep
        said the housewife
        going to the specialist
one knows what kind

but in the waiting room
she was racked by a plague
from the pots of the American
        miasma—our magazines,
        and so lady murmured
                        too quietly
even for her mind to hear:

*Reader's Digest,* please save *your* soul
and leave mine free to contemplate
eternity which must be more
        than I glimpse for myself now
        an endless promenade
across a field of baked old beans
        a cataract of dishwater
        regurgitated by the memory
of champagne I never drank
        and kings I never kissed

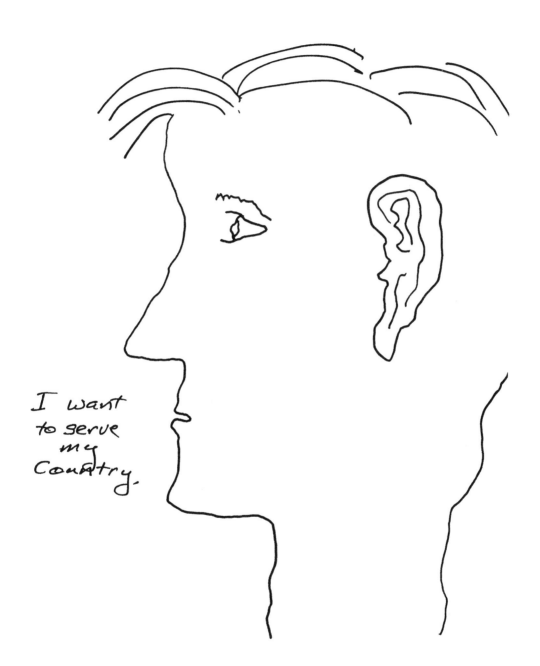

I want
to serve
my
Country.

Each time I think of some little thing
I can do to get ahead,
                        I feel as if
a foul fierce art from the nightmares
of constipation, the flaming waste of
stagnation
            (Chime! Chime! the Vowels!)
has forced its way
                        up up into my brain
and played the lyre from Hades' heart.

So I say to myself (I am growing deaf,
my dear) I say to myself: Boy,
you are getting ready to trade
the possibilities of the future,
otherwise known as soul,
                        for the ego,
the beans and the booze
    Remember: that Guy died for us.
But oh those dreams and how they burn.
    oh those dreams and how they burn.

Heaven cannot have a bitch
so royal as the root of my sweet itch.

# III

# Levels of Procurement

Johnny
 what
 can I do
 said the
 girl
I gotta pee

She was in a
 strange pad
 three hours long

Why just
come here,
princess,
 said
 Johnny
and I'll lead you
to the throne
who serves as sink.

Oh, Johnny
 said the girl
 you're funny.

The call girl
  walked along
  the bar
  escorted by
   a plump
      virile
      pomaded
      hip businessman,
      minor league Mafia,
  and behind them
      trailed a smell
       of stale
       sulphur.

      O sex
      you are dying
      I know
      but in
        whose name?
        and for what
                cause?

Do your duty
said I
to the beauty
as she turned
from love
(the act)
and sauntered
down the
hall
to
commune
with porcelain,
fluorescent light
and hound's sigh
of lavatory water
languishing
after the
souls
my beauty
chose
to taste
and flush
away.

Lie down with dogs
  you rise with
                figs
  said the lady
  who was the loveliest
    of all my pigs.

Call this poem
  the Market Place
      cried
      the red hair
            Negress
      who ball my ace.

Whores,
  I prate,
  make no ditties
    of my sores,
  for a pimp
      who shows no limp
      in the gait
          of his will
      has escaped
          all ill.

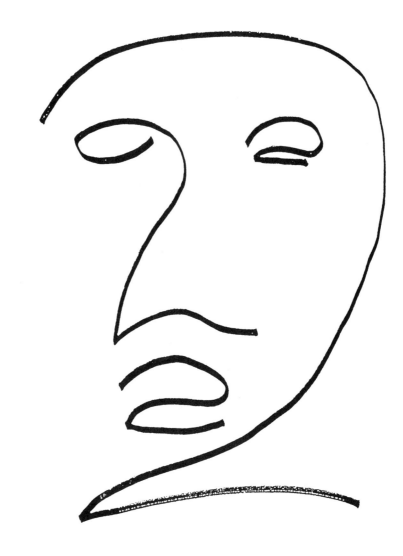

I'm tired of feeling
like a parking meter
said the sad street
whore.

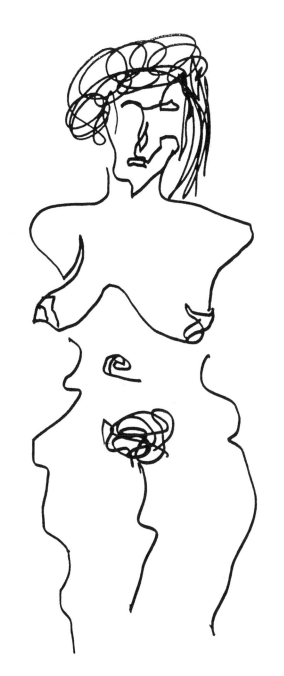

What did you expect?
The Mona Lisa?

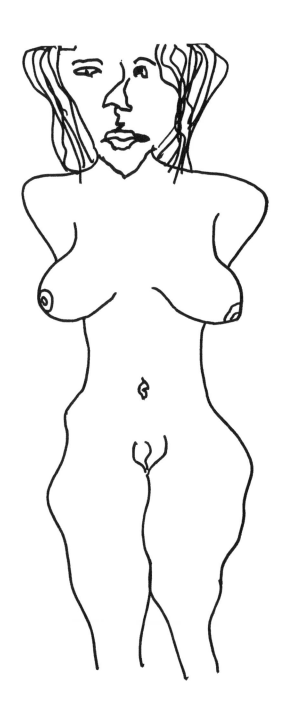

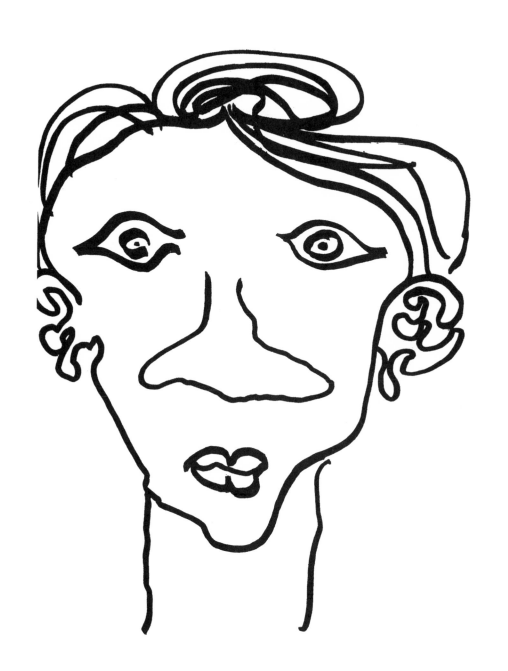

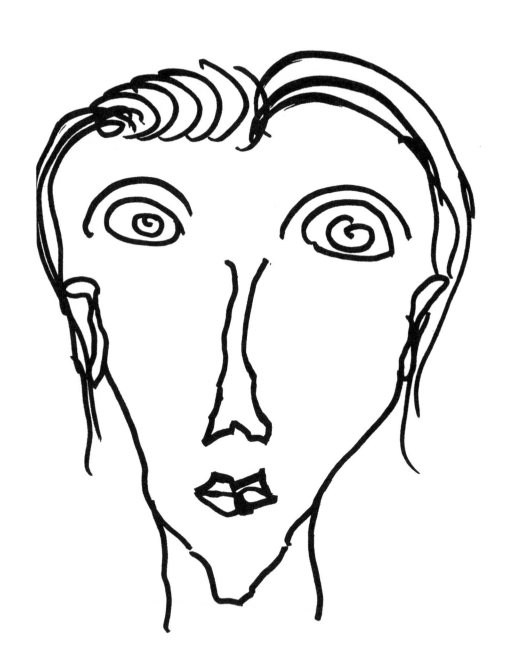

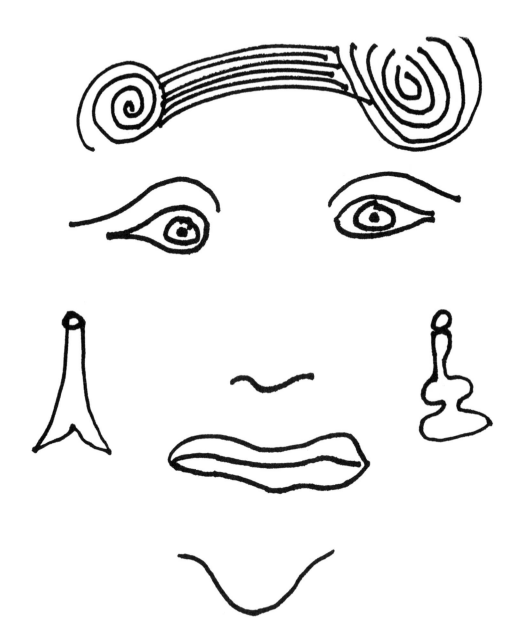

Yes, I'm Mary,
Mary Magdalene, yes.
Why, are you looking
for me?

# IV

## The Mediocre

We live in a world filled with all the wonderful things

    which did not happen
    all the passion never born
    when the sperm sailed into the sheet
    and left a quiver of empty arrows

    (did your little womb go pitty pat pat
    when midnight passed and I wasn't there?)

We walk in cities filled with second choice
you and me planned by calculation of the budget

    those neon signs cold compromise
    to cheat the savage dream of fire
    you do not control the flame
    until you put it under glass

    (all those lovely modern shacks
    fifty stories of steel and mass
    second choice in a new idea)

Is it better that prisons look like public schools
and airports shake their hips in plastic luxury?

    What a world of second choice besets the eye
    no wonder I am going blind says the Lord
    and oh that static in my ear

    (must everyone speak in an accent
    borrowed from another and all
    food die a second death?—freeze my juices
    seal my flesh.)

Devil torture me no longer, I will join
the vibration in the computer chip
    second choice of the wind when
    the spirits of the dead failed, you
    hear, to make us feel their hurt.

STATIC

Dah dit dit da dit dit dah
dah dah dit dit dah dah
dah dit dit dah dit dit dah
dah dah dit dit dah dah

Mentally cool and bright
Arms fly is the war song
Father of strong in your nave

Dum ditty, dum ditty, dum
   dah dah dit dah dit dit

Bold old gold is the grave
    which does not slay
    but reduces
    the best and worst
    to mediocre

    dit dit dah
    dah dah dit

    the mediocre

Superhighways
cut through
profit and
passion
and so
inhabit
the moon
before we've
learned
its mountain
road
which
winds
in
slow
curves
of the
root
toward
the ore
and her nugget

### 1.

A short hair is the chromosome of a short
story
said the sadist, an assistant protestant
professor
of creative composition. His words danced
like genes in the gism of a hate-filled lair.

It was the air before his face
down from the burning glass
of his spectacle lens
to the razor of his mouth

Kill talent by teaching it procedure
said the sphincter of his nostril.
Doctor Category, said the hair
within his nose, you stifle me now

But I will grow in your grave like ivy
entwining myself in the orbital
locket of your skull

For I, royal hair of the rebellion
am the last of a lover's nerve
the poet lover who created you
old gray-haired sadistic dad
I am father of your categories
     on the short hair.

Said the assistant protestant professor:
kill me, artist, curl your hair
into the bone of my grave
but I love your work

### 2.

Forgive my passion for category
I must believe that God is a tidy man
besides I will go before you
there are machines to replace me

Univac and One-Hole-Trac
They will bring death to your nerve
deeper than I ever dreamed.
Upon one another we fell sobbing

before the bitch of ice.
on came her machine. Yes, it said,
your short hair used to be the
chromosome of the short story

Now it is the fiber in fiberglass,
I gave one cry back clear back to
Coleridge on his lonely alp
for the horror of the albatross
    was its malignant wings

Death we have betrayed your sting
and licked the long dry tongue of
intellection
     much too long

We will die from anemia of the soul
in some plentitude of electronics
    and her suburb

Who stok my false teeth?

# V

# A One Night Stand

IN THE HALLWAY

My God,
   she said
I came
       in my
       hat

This time
     take your
         shoes off
           he said

My God,
     he said
     this time
*I* came
     in *my*
     hat

     well,
take it
     off
        she said,
I want
       to see
the baby
and how
      his hair
      will be.

You
    have
one
of
the
    greatest asses
in town
he said,

    Is
    it
extraordinary
    she
    asked?

No. It's excellent. Please do
                    stop

EATING IN THE KITCHEN

Do you have
    a comb?

Use your
    fingers.

A Logic of Love

Your eyes
        are beautiful
said my love.

Yes said I
        eyes of
        mine have
                seen your
                breast
                and so are
                        beautiful
(but one's heart
        was immersed
        in that
        calculus
    of the soul
    that measures
            the profit
            and cost
    of conversions
            from beauty
            to power)

Your eyes
        are beautiful
        said my love
        and have
                left
                me.

You're not large enough
            for a whale
and much too fat
            to be a shark

                    Porpoise
was her reply

Sleek pig
    thought the mind
    of my eye

Sleek pigs
        are porpoises
        said she
and began to cry.

## In the Mirror Is the Reckoning

Midnight
    said
    the
    lipstick
your mascara
    is mud.

        I know
           said the
           eyes
        but he was
           so
           attractive
        and he
        ended
        in the vast
           middle.

I think a bad cold is spiritual,
don't you?

# VI

# Unhappy Marriage

Worry-Wart
That's how I'm
known in
my family.

What's
he got?

(made
   a little
   money
Lost
   a little
   love)

Miami.

        She says
           these things

        I drop
           like dead
           meat-balls.

I want to
be a
fine
woman
and a
great
mother
to my
children
and
oh yes
you
she said

He makes love
like a little
pig's tail
thought she
all tight
kinky
curly cue
and full of squeal
why can't he
go
dark and deep?

Cheap!
beep beep a beep!
went the tail
of the pig
roar! went the
boar
and with a crash
and a snore
he went dark
and deep
into himself
and sleep.

HALLELUJAH!

Children
　　who issue
　　　　from
　　　　　　a matrimony
　　　　　　of the usual misery
　　　　　　go forth
　　　　　　into lives
which are best spent
　　　　　　in sin
　　　　　　said the Lord

You are
<u>late</u>
with the alimony

No more
bad news—
I beg of you.

# VII

## A Drunken Marriage

Look, she said,
   he carried
   her across
   the street and
   over the slush
why don't you
   carry me?

Because you
   got the curse
   I got worse
   we been married
      ten years
   and when you're
   drunk you say
      anything.

Whatever
dear Romeo
   said
   Juliet
   carrying
      me
   across the street.

The Good Lors
   gave me
   my
   pretty
   face
The Good Lors
   is full
   of air
like a polar bear
   with
   lollypop
   breeze,
   daddy.

why
why daddy
   why is the sky blue?
child
  one would have
   to embrace
    your formal
      Why
       with coronations
       of intelligence
       purer than
       the purest
       reason
         of my
         heart

Gin is not water
  but she is white
She makes
  you very
   drunk
  like mommy-daddy-dolly
    used to be
    when she-he
     fall
    boom-boom
    off the wagon
     daddy

Wanted
without
wings
is stone
   dew

Gray
without
grace
   is
   day
   without
   prey
   you're
   a king
   with
   feet
   of clay

You can't
   have
   a beer
   Momma
   says
   no

By God
   if I had a
   momma
   like
   you
   I'd
   never
   a
   reached
   the age
   of six

No,
lass
I'm
a
mandarin
   and reached
for a
beer
first
of the
blow

Wanted
without
   wings
   is
   stone
   do

Gray
without
grace,
day.

Gray
without
grace,
day.

Gray
without
grace.

yogurt
   mart
   church
   for
   art         blood
               and
               wood
               is
               bread

                     mother
                     menstrual
                     spike
                        and
                     mass

                                              fetus
                                              feathers
                                              food

                                     earning
                                     butter
                                     bone
                                     and
                                     break

                            fairies
                            father
                            flutes

homicide is hairy

                                   morons murder mutes

     Royal
       is
       the
       rat who runs the race

You let everything stand
until it's knocked over
and then
you go over
and write
your own
ruins

A Wandering in Prose:
for Hemingway,
November 1960

That first unmanageable cell to
stifle his existence arrived
on a morning when by
an extreme act of the will
he chose not to strike his
mother. Since this was
thirty-six hours after he
had stabbed his wife, and
his mother had come at a time
when he wished to see no one
in order to savor the woes
and pawed prides of his soul
(what a need for leisure
has the criminal heart), his
renunciation of violence
was civilized, too civilized
for his cells which proceeded
to revolt. But then it is
the thesis of this summary
that civilization spawns
its inner disease in every corner of
every church whose smell
is stale with the fatigues
of such devotion as lost its
memory on the long road
from ecstasy to
habit.

# VIII

# Drinking to Eternity

1.

Men
  who work
   at Time
  have a
   life expec-
   tancy
   which is
   not long
   said the
  young man
     from
  Newsweek

3.

But
in the
evenings
  they met
  and had
  beers
  together
  in Irish bars
  which looked
  the proper hair
    of fashion
   askew
   the type

2.

Those
  who
 bat out
  the poop
   for
the other sheet
  don't use up
  a thing
  in
  my scheme
  of space
said the
young blood
  from Yale

4.

And as they drank
    into
    warm
    spring
    evenings
    the remembered musk
    of wood-smoke at dusk
        brought
        tenderness
            to
        liberty
        and irony
            to fate
        and they
            would
        chant
        a song
                which went:

                we
                are
                saving
                our
                pennies
              to buy
              a bond
            to aid
            the drive
          of the United
        Corporations of Community
        who wish
        to construct
        a new
        and improved
        rest home
        for the
        pushers
        on the
          team

        Boola-
         boola,
         boola-
          boole.

1.

I'm rich
    said
    Irish
      derby
      slopping
        a drink
        to the
        floor

So I've always
      missed
      the pleasures
      of the poor.

        Taste his spit!
          said the sawdust
          it's a scandal
          and a shame

        Naught but outer limbo
          said the roach
            on his way
            on his fraught-filled
          way to the door
          and toward the
            stair
            of his own.

2.

When he reached
    the cracked enamel
    in the kitchen
       of his pad
he made a
      tour
of quarters
     leaving
     molecules
     like pennies
     on the oil cloth
        of the
         poor—
five molecules
       of scotch
      to every
          plate

    But the fumes had drunk
         his mind to stuff
         and roachie slept
         an emperor's sleep
         dreaming of previous lives
         in derby hats
       when he had slopped
         the whiskey
         to the floor
       crying for the pleasures
         of the poor.

There's one thing about you,
baby
    said Sir Cirrhosis,
of all the witches I've known
you're the merriest
    and he died
        with style.

He died with style
    said the witch.

Yes,
    said the wind
    which rose from
    the gin
give him honor in Hell.

When I was
   your age
  twenty
     seven
 a dame
    could
    say
I'll put
   a curse
  on
    you.

On!
   I would say
  put a curse
      on me
  and wonder
     why
     my voice
     would break.

not you
but your cure
do I fear
Oh my love
for your cure
is a
    curse
upon me.

## BAR TWISTS

I await her
  hot-breathed
  cigaretted
  garlicky
  version
  of all the lost days.

Cheer up
  whispers she
  (silently)
  hugging
  the other
  mugger.

Hurts me
  loathe chicks
  wife
  did me in
  I cannot
  forswear
  to gaze
  said the rage.

  Other drunks spit.
  Creepy girls giggle.

## EPITAPH OF A RAIL

I used to drink
until six
   in the morning
so I could make
      dames
and now I drink
until six
   in the morning
watching other
      guys
   make dames.
   Eheu Fugaces.
Which means:
   Fuck aces!
   before the fleeting
   years go by

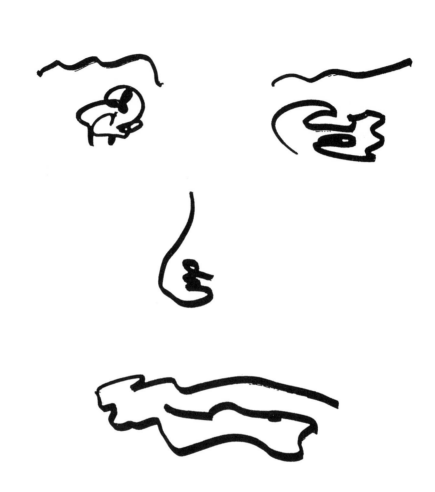

I am washed
by the sorrows
of love

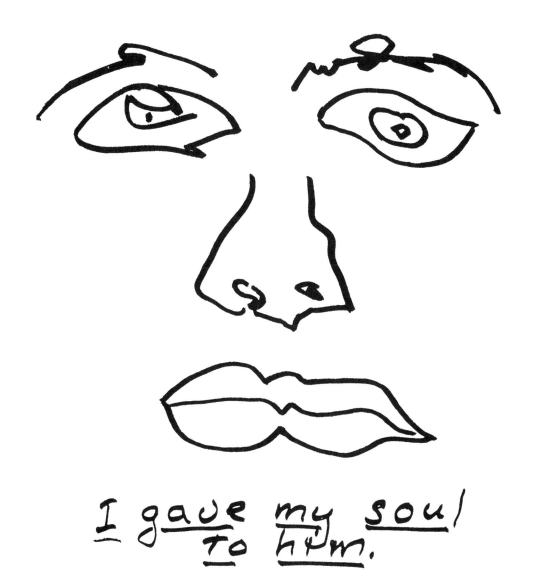

I gave my soul
To him.

# IX

# Intermission

### (During the Intermission
There Will Be a Variety Show)

## Ian Fleming Revisited

I had a spider once
and fed it neon tubes
until its web did gleam
like Las Vegas in the dawn
Roulette I used to call her
and the spider
drinking dew from grapefruit rind
to oil the knees
would smile and say:
every Roulette has her croupier.

A bird just pooped on me!

On Me, too!

"Petals on a wet black bough."

More petals

My head is in
a ↪ whirl.
I just can't do
arithmetic.

I was
supposed
to be a
baker's
dozen.

## SPORTS CHANNEL

Does the football team
        eat a lot?

Oh, I think so, Jim
        those football
        boys are
        are pretty big
        down there.

I sure remember
        when you
        two titans
        last met
        last November.

So do I.
        That fateful
        gray day
        in Green Bay.
        The weather was
        so bad we almost
        stayed in our
        hotel and ate each other.
        Our boys were
        keyed-up, I tell you.

Let's
stamp out
bad dialogue.

That's *your* problem
said the
toad.

NFL Quarterback

High
School
Quarterback

I've coached
football for
thirty years
and I can
tell you,
Consistency
is the name
of the game.

Yes sir, this is
my third year
in the Pro Bowl.

ILLUMINATION

why do
   you
   always
   have
      to
      go off
      on a
         tangent
      said his mother.
why can't you
      be
      nice
      and
      clean?
Look!
      Your handkerchief
         has a hole in it.
      Let me give you a
         new one.

Don't you dare.
This way
   I can
   blow my nose
   and see what's
   going on
      said Rimbaud
      at six.

the worst to be said
about mothers
is that they
are prone

to give

kisses

of con-
grat-
u-
lation

that make you feel
like a battleship
on which someone
is breaking
a bottle

Bar Mitzvah in the Suburbs

# X

## A. Interplanetary Is Trans-temporal

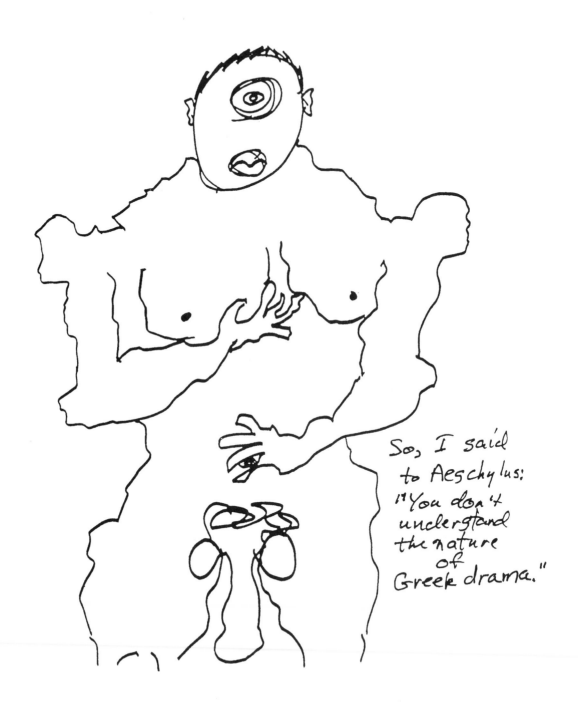

So, I said
to Aeschylus:
"You don't
understand
the nature
of
Greek drama."

NRA

He's gone the moment I get him in my sights.

Picasso said that the act of meeting me when he was a very young man was one of the most exceptional and determining events of his life. I concur.

PICASSO SAID
THE
EXACT SAME
THING
TO ME!

where can I
find a man
who is my equal?

That Salome!

Portrait of Picasso

as Salvador Dali

Of course,
    Mr. President,
        we
        are
        indeed hot
            on
            the track
            of the
            wonder
            disease

            and
            are
        now feeding
        tetra-phenomenase
        its dose.
Expect to save
        it
        and all
        genome
            compounds
            if the
        Internet
            does not collapse.

release
the anger
contained
in a fart

and there'll
be power
enough
to reach
the moan

said the
physicist
as he
assumed
the throne

I mean
the moon.

# B. In Which We Visit
# the Abductionally Challenged

The aliens did abduct
me, but I still feel
more or less intact.

I CAN'T SAY
THE SAME

It was unspeakable

SEINFELD

It wasn't
that bad.
They're all
bitching
too much.

Believe it or not
I had a romantic
interlude with
one of them.

seven

me

8  Three  Nine

Four

5

I can't
complain.
Their
interest
in me
was
scientific.

earth people
assume
that I am
trying to
hypnotize them.
I just wish to
understand
what they are up to.

# XI

# The Upper Classes

## A. Transatlantic

The Prime Minister said:
  The higher a man rises
  the more he must
  dissemble
  until he
    can no longer
detect his own lies
    of course by then
  everything
      that seems good
  betrays me
  and everything
      which makes
        me warm
        tastes foul.

Money
   is a
   river
     flowing
     downhill
       over
       hills
        of
        character
          in the
           rich

The secret of money
is that you have to
know how to allow
it to grow.

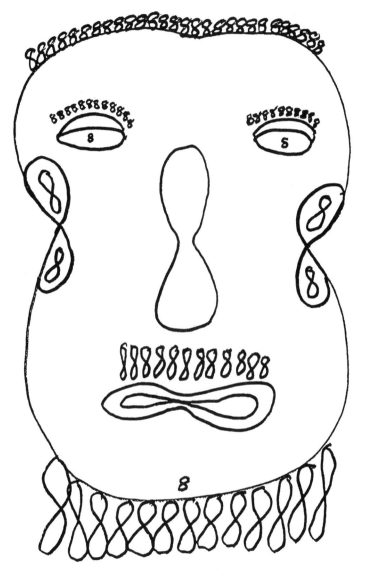

They call me Robber Baron
Go, figure!

You must meet her.
 She's rather nice.
    she's an
        absolute
        brigand
        who came out
        of a whorehouse
            in Baltimore.
Then she married
        a Jewish man
        from Macy's
And then my father.
Now she has
        the most terrible
        dining room
        in New York.
It's all gold.
Last year
        she finished
        decorating her house
        and charged
        one thousand dollars
        a plate
        to let people in.
No drinks.
Of course
        it was for
        a marvelous charity
            called Baskets
        For people
            without
            arms
            or legs.
    Isn't that nice?

I love Bobby, Bobby's divine
   The Windsors came to
      see him
   and the Duke
      kept calling for
Bye Bye Blackbird
over and over again.
It was a glorious night.
I borrowed mascara
   from the Duchess
before we were done
we were crying
     so hard
      even the Duke.
How were we to know
   that the West
     Old World
   would shiver from blight
   and I would turn
      to a Prince
      of the Congo
   saying: embrace me
      darkest delight
for in your firmament
are stars.

Oh blackbird
   do not banish us
   banish not
      the lovers
      of Bobby

when he sang
   Blackbird
     bye-bye
for can it be
   we heard
   the chord
   of the cannibal
sharpening his knife
   on a blooded stone
   and wept for you
      as well as us.

Young winners
   make weak old losers
   said Bobby
     removing his mask
     to show
     he was now
      King
    of our
      Congo.

## DEFINITION OF A LADY

She grasps
the root
while kissing
the bud

## DEFINITION OF A HERO

He
thrives
in
dikes

Evil
fingers
up
and
down
my
spine
remind
me
that
sex
is
not
always
divine.
But
sometimes
it is
with
the most
astonishing
collection
of
horrible
people.

## Ode to a Lady

Cold and swinish are your crafts
Mean and nasty, foul your arts
The spirit of a lover you would never kill
'Tis tastier far to deaden him.
   Yes, maggots are your pets
     and garlic your bouquet

Cold and swinish are your crafts
  a pestilence on me
For I have primed my iron
  in your lore and now
your faults revealed
  my eyes are blinded still
   by the image of a woman
  who is a virgin to my touch
  and never smiles the lover's dirty grin
  of sweets we shared
   and share we will again

No, you are a work of art
  pristine, inviolate,
  shiver of midnight away
   from the touch of my tip all
   fingers stretched

You call to artists
  in other lands
  singing sweetly:

     Create me
     dear singing loin
     of some manly harp
     create me
     for I stifle where I stand
     and lady-like
     must drown the moment
     in the lake of much too many
     who leave me lazy like a snake
     So, create me, dear man,
     beyond my eye.

And I answer:
   snake and foulest bitch
   swine of a hundred feet
   I am your artist across the seas
     and love you, heart,
      because you are purer far
      than all your arts
       and all your swilling crafts,
     purer far because your heart
      dared to call
      when others—
      cats, grand dames,
      fraises fatales,
      and all the avaricious humps
      could think of nothing
        but flight from me.

    Come back,
     says piggy
    Can it be, poor harp
      Can it really be
    that you are the voice
           across the sea?

    Yes, come back, says swine-song in your heart
    Come back, come back, come back
    For names you've called me
        far and wide
    Wine of a hundred feet
        Sweet lord you're kind
    Yes come to me honey-bee
        and I will kill you.
    Over here my lad,
        God, you're bad.

## MARRIAGE À LA MODE

Cook for him?
Of course not.
We eat out
  all the time.
He's gotten fat
He's gotten
     very
     fat
     *longing*
   for good
     cooking
     said the Bitch
  in a voice
     of absolute
     tenderness for Mr. Bitch
     curious fellow
     her husband.

DEVILS

One of us
will
be
better
looking
when it's
all
over.

# The Upper Classes

## B. Witches and Warlocks

The most
   eligible
   bachelor
   in London
   is a category
   conceived
   by presumptive
      witches
      weary
      of doing
      without
   their widow's weeds—
   whispered
      the epigram
   to the boutonniere.

Go fix the flowers fuck-face
      was the King's reply

I'm fast
  becoming
  a goose
    said the bitch
    blinking her eye
    to the beat
      of my
        intent
        light, deliberate and dry

I hate to have a ball
  which goes de trop said I

De trop, or not de trop
  dare your
  deliberations
  go deeper
    ducks.
  for love
    which is light
    and dry
    makes me think of money
      and her dirty bucks.
      So waltz me
  around again Willie
  hard dark and deep
  the keys to the dungeon
        are buried
  in mummie's
  murderous
  keep.

You bruise
  my
  catatonia
  said
      the saint
      to the witch
  after he had
      fallen
      so far
    as to nod
      assent
      to a
      shitty suggestion

Is that all
  asked the witch
  accoutomé ma foi
      to eat the shit
      of the
      superior.

The saint forgave her
  and kissed a sore
  content with the
      notion
    it came from mort.

Deep in my dungeon
  I welcome you here
Deep in my dungeon
  I worship your fear
Deep in my dungeon
  I dwell.
I do not know
  if I wish you well.

Deep in my dungeon
  I welcome you here
Deep in my dungeon
  I worship your fear
Deep in my dungeon,
  I dwell
A bloody kiss
  from the wishing well.

1.

The air was full of curses
  looking for no fight.
    The devils and the witches
      were all alone tonight
      save for a saint
        who was sad.

Mad, mad, you're mad,
  cried a lad in the garb
    of a girl
  Saints are not sad
    but sadistic.

Cruelty is the kindest wound
    for dung, replied the saint.
    Go forth and sin
      in such a way
      you need not run
        at break of day.

Not one said yea.
    Still, the saint merely sighed
    he knew a saint
      must not aspire
    to the courage of a god
    nor try too long
    to bear such pain.

Besides, the saint was vain.
It was the drop life left
    in his humility
    in the couloirs of his humility
    in the catatonia of his senility
    in the crease of Carmen's ear
    in the crease of Carmen's ear.

I am brave by an act
   of will, said the saint
   my nature is to fear
O saint even you must fear
   the crease of Carmen's ear.

                    2.

For Carmen is a cutthroat
   Carmen is a queen
   Carmen sings of passion
         and blows her breath at me.

Carmen is a royal whore
   Carmen is a slut
   Carmen has a mustache
         and smiles at flowing blood.

I knew Carmen when she was young
   Before her mustache bleached
   A colored flag around her neck
         she kissed the pirate's fleet
         and seduced herself to me
         and stole from me a steed.

Her head upon the pillow
   she caught her flesh to mine
   And went off at a gallop
         some galley's keep to find
         presenting me her ear
         returning greed a fiend.

Oh, I was a young man
   Cold, evil and strong
   And few were the ladies
         I couldn't dog, dog-
         bitch, you're in my bed
         and cue them out half-dead.

3.

Five children started in my land
   Six across the sea.
   None knew my hand upon
     his head. Royal bastards all.
     One swore my death was in
her vow. Loyal bastards royal.

But Carmen was a crueler siege
   Than all my evil gathered
   And tore the heart right out of the ram
     while all that's vain was shattered.
And now I am a saint. (O pity me.)
Now I am a saint. (O pity me)

   I stare into the eyes
     of devils,
       devils dark and foul
   and look them down
   and steal their ground
while in me tolls a hollow
   by the heart
     of Carmen's ear
   near the heart of Carmen's ear
   that scar on horror's breast
     which fears no fire
for death to Carmen is Devil's dare
for Hell to Carmen is heaven's mare:

   a trot away from this flat world
   where saints and witches stale
   and war's too whored for open fight
   swears the heart of Carmen's ear
   swings the hooves of Carmen's steed:
     ride, ride, ride with me.

### 4.

Come ride with me into my land
Down down along my crease
And we will live forever
    in the marrow of the beast
    and we will live forever
    in the sweetmeat of desire
Oh we will live forever
    In the sweetmeat of disease
    oh we will live forever
    by the steeps at Carmen's knees
    we will live forever
in the crease of Carmen's ear
in the crease
in the crease
in the crease of Carmen's ear.

# The Upper Classes

## C.  Camembert and Caviar

It's a fine wine
  hearty as one drinks it,
                    peppery
        yet it seems
            to come
              florid
              and
              soft

Yes, I answered,
  we have an
  old peasant
  saying:
It's a fine wine
            but the devil
            pooted
            in it
            once.

The second bottle
   was
   Sierra Blanca
   a California
      Sauterne,
   with a moldy
   label
and a green
   rusted cork,
age and
   color
   of
   cobweb.
So we
   chose it
over a fast
   dry
   cool
   professional
   blonde
   from
Bordeaux.

Yet when
   the
   nectar
      crested
      over
      the eddies
      of fume
      that rose
      from
   the dust
      of the cork,
      the wine
   was sour
      and
      squalid
         like
      bad breath
on a good goose
   with bad teeth.
Oh well,
      we murmured
      never fall
         for a
         pretty face
            again.

Nonetheless, we agreed: Domestic may be the wisest choice
For the ocean voyage spoils the wine.
It is the movement of the waves upon
the memory of a grape
Water lapping water is too sensual to the touch
wine delivers its love to the bottle
before the trip is out.
Ohhhh. Unhappy continent
livid America
the taste of wine, of foreign wine that crossed the sea
is like a taste of love the second time.
Poor wine said Lady Grape shedding a tear.

Vodka is fine
we agreed,
one can keep
one's character,
it doesn't do
funny things
to the style
of the soul
departing,
it doesn't
get into
the end
of one's
fingers
and leave them weak.

You must never let
anything
get into
the end
of your fingers
but
     Love
said evil
getting up
to get another drink.

The caviar is marvelous, however.
(I do love the taste of the soul
in each little egg.) Still!
One does have to entertain the thought
that learning so much about the deep
                              perhaps,

oh dear God no,
perhaps next life
I will be a fish.

fizz
fire
flash
foo
flesh
    went the bubbly.

Como no, Senor
    said the sommelier
    I know some fine
    accommodations
    in the sea.

If poetry is the food of the soul
then some poems are like pot roast
lots of meat, pannikins of gravy and
a great deal of taste all very
much the same.

        Other poems are fishy
tang, pepper, weed, and green as the
sea. I know a few which stick to the
fingers. Poetaster in patis-
serie. But my poems—
            I want my poems
to be like bones. Bones make it possible
to stay in good form.
          And there are
poems which taste of grass, air, earth,
rock salt and old lady granite in the
minerals (not to mention all
the dairy products, milky poems,
vegetables and gourds.)

        But I want
my poems to be like bones and shine
silver in the sun.
         For poems which
are like bones crackle in my teeth.
Look for the death within the death.

Since Camembert is the King of cheeses
foul, corrupt, redolent of old uses, dirty royal feet
and wealth beneath the ground,
then Brie becomes my Prince
said the air of morning to her appetite.
Still, said Camembert, monarchies produce architecture,
princes bastards
and morning speaking to her appetite is mud
to those who drink with Faust at night
Yes, adventurers gargle the sour blood of dukes
and eat me says Camembert
Power is nothing without the smell
of a royal crevice at your finger.
Oh, says Brie, nothing is so lovely
as the milk of morning on my mouth.
Do not let the world sodden us with its liver,
its poor colon and a smell of the hoarded past
Good architecture comes from young men
stealing the better half of form
from the royal round rump of some majestic lady
who smuggles jewels to the prince
and embezzles deeds from the King.

One cannot give a funeral service to the fart
       and yet there are broken winds that walk the plank in pride.

HYMNS

The sweetest
song
I ever heard
was
the sound
of each
tongue
on the
other's
bung
said a choirmaster
for the Devil.

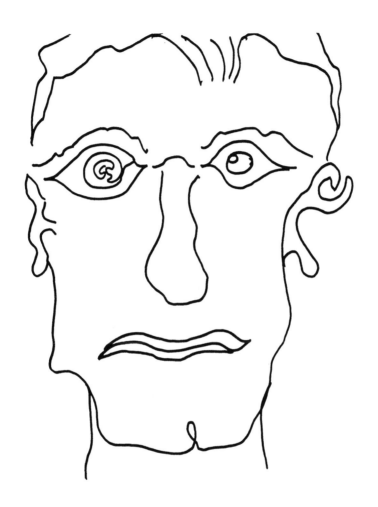

It's not easy
to be a priest
these days.

# The Inaugural Ball

## 1.

There was a time
        when fornication
        was titanic
and the Devil
        had to work
        to cheat a womb.

        (pride of his teeth
                on a root
                long enough
                        to
                pluck it out
                the green wet sea
                of the pussy slue
                and down a falling
                        flight
                of cellar stairs
                hard, dark, deep
                into the maiden brown
                rooting out the bowels
                which fell
                like assassins
                        upon the white foam
                        of God's arrow)

2.

There was a time
    when fornication
    was satanic
and the Devil
    had to work
    to cheat a womb.
        (licked the liqueur
           of milady's loot
           off a hot feathered face
           and sobbed in despair
           as God won the race
           to shoot the fury
           of his intentions
           to the proper place.)

3.

But now the Devil
    smokes a cigar
    and has his nose
    up U.S. phar-
    maceutical
The assassins
    who fall on God's
    white arrow
    give off the fumes
    of chemical
    killer bedded
    in vaseline
    as heroic
    in its odor
    as the exhaust
    which comes off a
    New York City
    Transportation
    System Bus

4.

I do not want
    to believe it.
(Ay, no quiero verla!)
  that the scent
    of the clerk
     at Merck
      and
       Merck
    is the last
      of the Devil's odor.

No.
    I want
to declaim
that the time
    will return
    when
    Lucifer wrestles
    the Lord again
      for fucking
    all glory
    of Heaven's vault
       in flame,
       and
       mandarins
       mad
       with
       fright
       at fucking
       and God's
       black
       light.

# XII

# The Lower Classes

The Hard Hat

The Hard Hat's
best friend

I'm the
best friend's
father. And
I can take
both of
them.

Yes I'm in the Militia. Just call me Lucky.

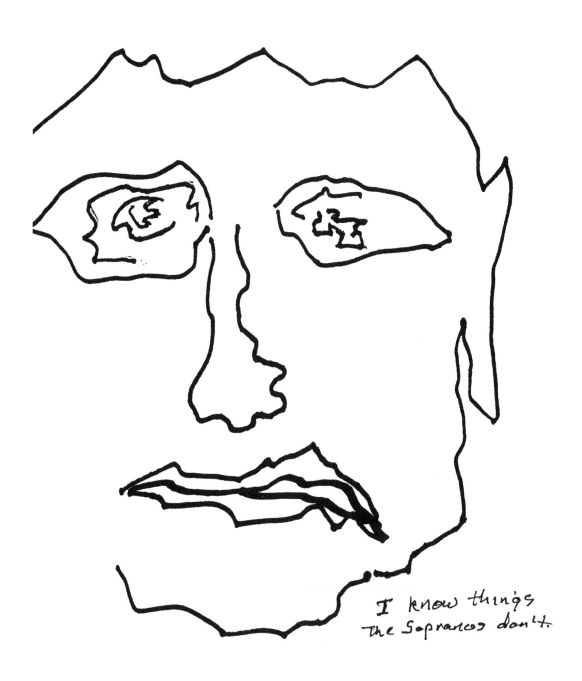

I know things
The Sopranos don't.

There was a meet for the boys
The moolahs the mozzers, the Maf, the Coast and the Nose
even the bonze and the dunes.
They were in to get acquaints for a new soft commodtz
and general affiliate.

How, said the Coaster to the Nostrand
do you think soft sell began?
Well, I'll tell you said the Maf; we said to the dunes
whaderya trying to shove that shit
    down people's troat for?
Slip it up their stroonz
    you asshole
Strike a match!

Said the dunes to the Maf,
Whaderya want to give me a hard-on for?
you have hurt my feels
how much can the heart of my feels take
before the heart of some other Guinea's feel
    is forced to break?
Listen, said the dunes to the Maf—you're a dunze,
Don't get hit!

So they had a ruining
They had the runs.
That was some thunder.
Those fartsaroons came close to eating all the prunes.

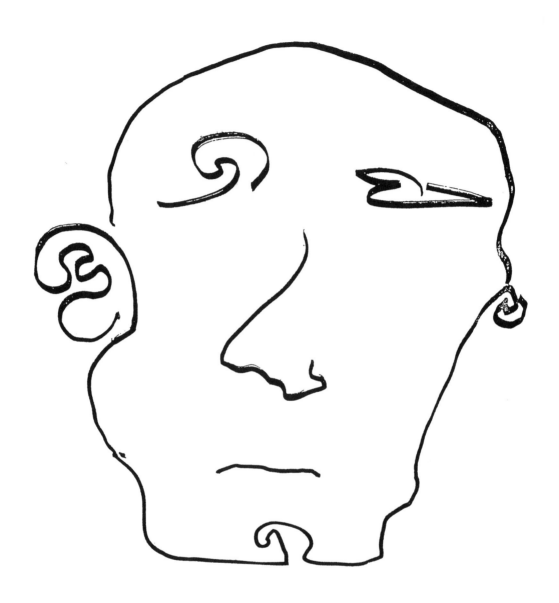

You don't know who I am
and you don't want to find out.

Ditto!

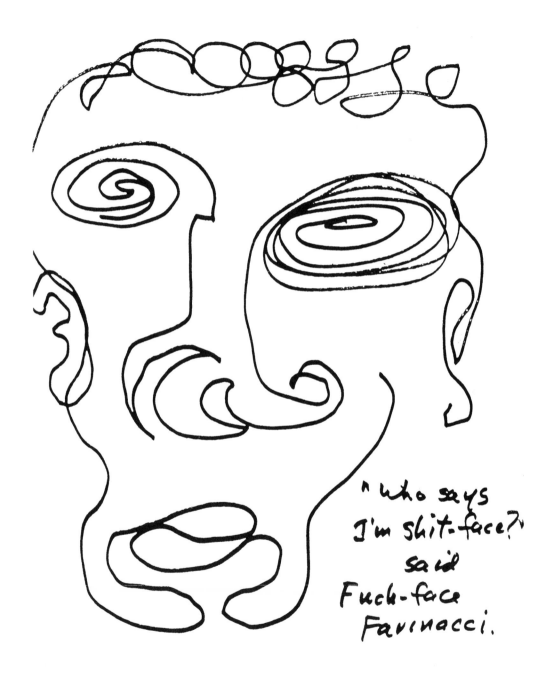

"Who says
I'm shit-face?"
said
Fuch-face
Farinacci.

I'm Ass-face —
Fuck-face Farinacci's
best friend.

KEEP YOUR NOSE
CLEAN
ASS-FACE

They ask me if I'm
the consigliere.
I tell them — keep looking!

In New York
it's not
enough to be polite,
one must
be
brutally polite,
to wit:
variations
observe
the theme
of foul
economy
Shithead
follows
up your
bunny
honey
in
balance
and pro-
priety
Jew
bastard
if said
in a
Village
bar
is as
gentle
as
spade
creep

Fuck off
can be
returned
with
three
stiff
fingers
to the
plexus
or the neck
The
rule
is
keep
cool
This
is
New
York

Now
  these
  children
  want me
  to roast
  their tea
  said
  The Man
  with the bag

Do they
  think
  I'm a
  mother
  with
  shades
  and a
  furled
  umbrella?
  Go to sea
    Jim,
  I have
    something
    in my
     head
    that
    would
    really
    kill
    you

Another orphan
    said McCarthy
    let's have a high mass
    and kiss her ass
    before we kick
    her cunt in,
    sister superior.

Ooooooo
Is this poem good for the Jews?
    asked Reverend Godspee
    of the Inter-Faith Council
             for
    The Committee of
Hearth and Heart, Share and Care

Kick his cunt in too
        said McCarthy
Reverend Godspee is
        a Communist

You're fucking aye
        said all the louts
        in all the bars
        in Queens
        and they were right
        for once.

You
*can't*
and you
*won't*
print that,
    said
    the Lady who
    was running
        for office
        in a voice
    that
        released
        half
        her
        souls
from prison
        and
        dropped
        them
        into
        Hell.

Noblesse
    Oblige
has one rule
    and
one rule only

You must be
    so nice
    so bright
    so quick and
    so well turned
        that
no one need
        tell you
        a second time.

Tell me what?
    that the world
        is well-lost
        for love
    and the upper
        classes
        are the
        law above?

I tell you this:
    if the
    upper classes
are kin to God
        in style—
(which is one hypothesis
        we do not ignore:
            how else account
        for elegance?)

if the
upper classes
are kin to God
    in style
then God has no love
but guilt, nor a style
apart from fashion,
no courage but to
do in duty
        what
one does not desire
and no worth
but for His love
        at beauty

For there
    is noble's work
their plea:
        that they
love in truth
with all sense
    of Christian
    love
divorced from self
the air of beauty
    and her pomp.
The poor know naught
    but death
they do not free
they obliterate.

Stripped of its
    distinctions
life is a flat city
    whose isolated spurs
    cut the sky
    like housing projects.
Think of the air
    whose heart is bruised
    by touching such artifacts.
    (Does the cutworm forgive
                the plow?)

I tell you, say the rich,
    the poor are naught
    but dirty wind
    welling in air-shafts
    over the cinders
    and droppings of
    the past, their
    voices thick
    with grease
    and ordure,
    sewer-greed
    to corrode the ear
    with the horrors
    of the past
and the voids
    of new stupidity.
One could drown
    waiting for the poor
    to make
    one fine distinction.
Yes, destroy us
    say the rich
    and you lose
      the roots
      of God.

Destroy them
    say the poor
    we cannot breathe
    nor give
    until we etch
      on their rich nerve
      the cruel razor
      and heartless club
        of our past,
    those sediments of
      waste
      which curbed
        our genes
        and flattened
        the vision we
        would give
        the chromosome.

Yes, destroy them
    say the poor
    burn them, rob them
    gorge their tears
and such half of beauty
    lost to pomp
    will flower
    unglimpsed wonders
    in the rose,
    will flower
    unglimpsed wonders
    in the rows.

I wonder,
    said the Lord
I wonder if I know the answer
                any more.

Panhandling
the Bowery
on Sunday aft
with gray sky
and no butts
we had an
argument
over the
      merits
of frozen food
versus canned

Canned is awful,
I said, it comes
out half dead.

Yea, said Red
      but
      frozen
      is stone.

On the meat of the rich
And the urge of the poor
The purge of the ore
And the grease of the bitch
A lady was burning
A whore was a-scorch
Gorge was the cheese
And ass the itch
Of Pussy and Pick-nose
And swish out the twitch
Deep hurted the liver
Raw buried the sauce
Hotshit the hurricane
Herded the gourd
Howligan, hooligan
Hurry up all
Tonight is the night
Of the Hip Hole Ball

Perfume and heart
Snatch squinch and squeeze
Ear-wax and dingle
Fuck tit and dong
Fling a hole on your point
And sweeten the joint
Tonight is the night
Of the Hip Howl Ball.

# XIII

# Hunting for Poems

Men who go out for game
hope to find in our blood
the poems of their flesh
said a deer in her pain

As a poetess, I try
to rise above flora,
fauna and gender.

Even the seeds of
sensation
                are
thrilling to me.

Spleen?
Yes! Bad
poetry always
inspires spleen
in me.

Some of
my ideas
are impossible
        to describe. I'm so
            afraid
            that people
            will squash
            them.

A crap,
    said
    the
    pedant
    picking
        his
        paws
    is an
idealist
    who has
    not yet decided
        he is worthy
            to be considered
                a shit.
Mon dieu, Feinspan,
in terror, I
    exclaimed
abjure the
Anglicans

*"Our concern was speech, and speech impelled us*
*To purify the dialect of the tribe*
*And urge the mind to aftersight and foresight."*

aftersight and foresight
the sound is dull
 in the ear
 like a bruise
 on fruit or
 taint
 in strong
 meat
So curious a man
 this Eliot
exquisite, pertinent,
yet dimmed in his climax

aftersight and foresight
 hole upon hole
 a curse
 upon prosody
 even when T.S.
 sponsors
 the hole.

I have a simple mind
   and write my words
   to sweep across
   a broad cloth.
Rich talents go often
   to misers who make
   diadems of chocolate.
      *the emperor is*
      *the emperor of ice cream*

Yes, the rich speak only
   to the purls of their lace.
   I want the whole wipe
   of the cloth

Or do I delude myself
   and merely spit like
   a hoodlum
   into the wake of phaetons
   that drive away?

A writer who
has power
should use it
to extract
such benefits
from his
publisher

as
give
his
words

room
to
breathe

I want
my
l
i
n
e
t
o
strike
l
i
k
e
a snake

A snake
can't strike
in a box

you break
up your
line
like
ee
cum
mings
I notice

n
o    heb    re   a
ksitu       pd
iffe
r
e
nt

I am looking
for the
fish who
swim in the
spaces

ee likes the
herbs
in the
letters

r)
ette

besi desh e'sb

Falling in love has
left my work in a mess.

I have no desire
to change. My
spirit is to be
critical.

I'm very
critical
until I
take off
my clothes.

Some poems
    are mild
    and pleasant
    little children
        who bear no title
            and need none
        one doesn't notice
            their
            nakedness

A title
    is not
    a hat
    but
    a suit
        so
    sometimes
        I leave
        it at the
            bottom of
            the page,
            for
        I don't want
            all these poems
                to be
                unclothed.
                Some should be
                    standing
                with
                their trousers
                dropped to
                    their shoes.
Of course
    by this logic
    a title at the head
    is like a dress
    lifted over the breast

Poems
    written by
    masochists
     flop like cows
       in the meadow.
        Take pity on me
         they cry, pay
         attention, I
         am so sensitive
         to nature and
         full of milk

Poems
    should be like pins
    that prick the skin
             of boredom
             and leave
             a glow
          equal in its pride
          to the gait
          of the sadist
             who stuck
              the pin
              and walked away

She's a
bitch
said
the witch
in a tone
that clarified
the eternal meaning
of the consonants.

No, your honor,
  said my voice.
  Without vowels
  there is no
    justice
    in human verdict.

We were speaking
  of bitches
  said
  the judge
    Ignore eternity
      and the color
      she gives to legal
      utterance
      It is better
      to chase consonants
      than vowels.
consonants are
  fact and force
  clear as compound
    interest

  vowels are hot eyes
    in hard bodies
    bleeding for trouble.

But I replied:
Eternity is first heard
      on the pigeon's wing
      of a sigh
      breathing alas at
      all that passes
      and does not live
  Judge, Your Honor,
    Bind me over
    to the next of size
    for I do dream
    that love there may be
      in human flow.

DANGER

Words in the nerve
of becoming
are feathers
    of eternity
    (insofar
        as a poem may become
        the death of another
        who believed the poem
        and so ended in some alley
        of bad venture
        with the wrong foe)

                    those
who are alive
look to others
for a mirror
half dead, one drinks
                    alone at night
                    and writes poems
bad ones said self
sorry pity
should write so sad
and beg for tears

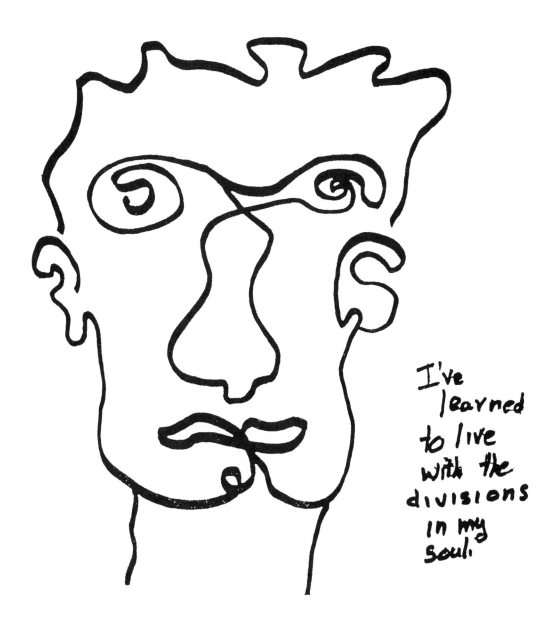

I've
learned
to live
with the
divisions
in my
soul.

1.

It would
   be
an aid
if the
   blind
   came
      to the
      game
because
their ears
   are
   clean
   said
the dream.

2.

I would
   be
afraid
of those
   who
hear and
do not
   see
   said
the word.

3.

I am
   in
love with
those who
   come
with their
wound to
   me
said the
mood
   for
those who
   see
and do
not hear
   wound
   others
   with their
   voice

4.

Those who
   hear
and do
not see
   give
   alms
   to Eve
   and
   other
   ill
   said
the peace
that comes
   from
the police.

Let
　at least
　　a drink
　　　be
　　　　named
　　　　　after me
　　　　　　said the poet
　　　　　　　sealing his
　　　　　　　fate
　　　　　　　　for
　　　　　　　　　no bar
　　　　　　　　　　in the land
　　　　　　　　　　　would tease
　　　　　　　　　　　　the police.

# XIV

# Politicians

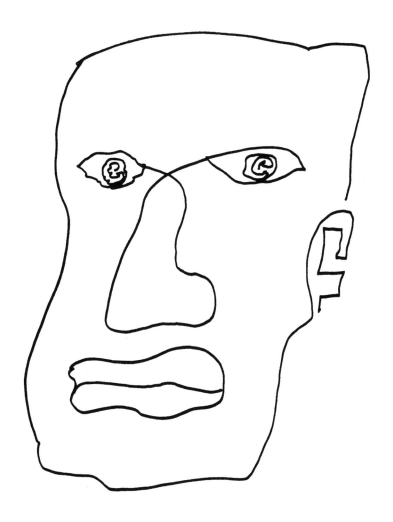

We're looking to mine
the bottom line.
Down where the Undecided
hang out.

I see no reason to put
my trust in any politician

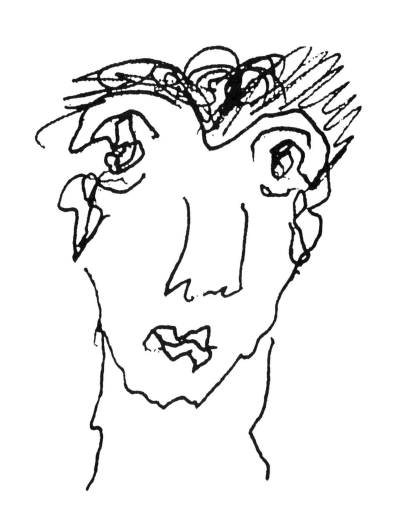

It was easy. I never
spent time with a man
who was of no use to me.

OLD
BATTERED
BILLY-BOY
CLINTON

MADELEINE
ALBRIGHT

My knowledge of foreign
affairs is immaculate.
Kosovo! Kosovo!

People
keep
asking me
if I'm
Ariel
Sharon

People keep telling me
that I look like George W.
but I opt for Superman.

EXODUS

Goodbye America
Jesus said.
Come back, boy!
We cried too late.

# XV

# Hemingway Revisited

Jake pissed
with
stern
loneliness
leaving
a fierce
smell
of the past.
His future
was not
so empty
as he declared,
a girl with
music and grace
tender of face
was waiting
for him.

Hey—
  you
    sleep
    deep—
  but what a sight
    see
    you
      soon
     beautiful
    I hope

Catherine
found this note
by her telephone
on awakening
in an empty bed
after a one night
stand and she called
her best friend
to say;
        Guess what?
        I feel like
          Earth
          Mother.

Catherine never blushed
until
she smelled
the fine cheat
in
the line
of the succession
and then
she flushed
furiously
for she thought
the smell
adorable,
it was
so
rich
to rise
from
the poor.

We really ought, Catherine said
to be able to stay together
without making love
all the time.

Yes, said Jake,
I'm sure it's my fault.

Yes, she said smugly
you smell so greedy
                and good

Swarms and swarms
  of love
  smug, smug, smug.

You may not love me
                    Jake said
          but I love you.
Well, I love you,
          said Catherine
          so
          bad luck.
They loved each other
          very much.
They had not taken
          a good wash
          in three weeks.
It would have been
          the next wrong
          to murdering
          a child.
What the hell
          they were both
          thirty
          forty
          tired, tried,
          sad, foul
They thought they
          had betrayed
          something
          forever,
And She forgave them.
Or thus they hoped.
          So, bad luck
          muttered the
          horror
          of old
          habit,
          We will die
          if we lose
          our love.

Mangled, morgued
birched and bruted
    they were
    hawks
    upon the mood
     of their
     own blessing.

So they scattered,
    waiting
     for the
    curse.

              Slack the yaws
                 tight the jaws
                 hurricane
                 the air
                   of waiting

Will you play "The Lady is a Tramp?"

I feel
   like
I've been
   through purga-
      tory, Catherine
            said.

   Sometimes
   I think
      it won't
      be bad
      when
      we die
      because
   we've served
      part
         of
      purgatory al-
            ready.

Yes.
   It's been
      bad.
      But
   twelve years
      ago
         we were
      good.

Oh, darling, good, she agreed,
                     so good.
      I used to think
         it would
            be always,
            but it wasn't, it
               turned out
               to be
               such a little
               taste
               of
               heaven
               for twelve
               long years.

A little taste
      of heaven
  is all we get, baby,
  said Jake.
  through the
  microphone
  and plate
      glass
      window
  of the visitor's
          room
     under
    the shotguns
    eyes
    bellies
    and blue serge suits
    of the guards
    who guard
the sacred heart
of the Republic.

# XVI

# The Harbors of The Moon

I used
to think
my life
would be
a
destiny
and now
I realize
   it's but a fate
said a man
I met
in Bellevue
for
stabbing
his
brother
with a
kitchen
knife.

One
nerve
screams
before
you
fall
said
the
ledge
on
the
window
of
the
nineteenth
floor

DEATH OF A LOVER WHO LOVED DEATH

1.

I find
   that
   most
   of the people I
           know
    are immature
    and cannot
          cope
          with reality
    said the suicide.
His death
   followed
    a slash on each wrist.

He coped with
        reality
        well.

2.

It was unreality
    which waited
    on a midnight trail
     in that
     jungle of eternity
     he heard murmuring
    on the other side.

Oh, night of the jungle,
   God of mercy
    wept the suicide
    do not ask me
    to reconnoiter
      this
       dark
       trail
    when I am now
      without
      hands.

## In the Jardin Exotique of Eze

In the Jardin Exotique of Eze
the cactus come up from the sea
like an anemone wooing a spider
or a pygmy with a blowgun dart.
Silently they smell the breeze,
      invertebrate,
their memory as long as the tripe of the Mediterranée.
Was it once or never? that a God from deep waters
              dreaming of the moon
fell in love with a gleam from the midnight sky
who, intoxicated with herself
and the rapture of the depths,
like a daughter most fortunate in family,
beautiful, spoiled, innocent of alarm,
wandered down an alley
dark as the pitch of blackest frustration
and there was trapped by the sound of need
in the murmur of an ape.
So did the God of dark waters woo a moon beam
and from their love leave a seed
on the spume of the wrack
which washes a desert shore
Cactus,
mad psychotic bulb of light and dark
      spy of the deep sea
      intimate of the moon

your form inspires nausea
for love that dares too much
and has no soil but sand
flowers spines of lunar hatred
shapes tubers on the leaf
and gives no wine but visions from peyote
of ether and her gardens
which burn with the
death of suns
and phosphorescent nights.

I think if I had three good years to give
   in study at some occupation
   that was fierce and new
   and full of stimulation
I think I would become
       an executioner
  with time spent out in the field
   digging graves for bodies I had made
        the night before.
You see: I am bad at endings
my bowels move without honor
  and flatulence is an affliction
  my pride must welcome with gloom
It comes I know from preoccupation
  much too much with sex
Those who end well do not spend their time
  so badly on the throne

For this reason I expect the task
  of gravedigger welcomes me
I would like to kill well and bury well
Perhaps then my seed would not shoot
  so frantic a flare.
If I could execute neatly
  (with respect for whatever romantic
              imagination
gave passion to my subject's crime)

and if I buried well
(with tenderness, dispatch, gravity
and joy that the job was not jangled—
giving a last just touch of the spade
to the coffin
              in order to leave it
quivering
         like a leaf—for forget not
coffins quiver as the breath goes out
and the earth comes down)

Yes,
if I could kill cleanly
and learn not to turn my back
on the face of each victim
as he chooses
              what is last to be seen
in his eye,
       well, then perhaps,
then might I rise so high upon occasion
as to smite a fist of the Lord's creation
into the womb of that muse
which gives us poems
Yes, then I might
For one ends best when death is clean
   to the mind
              and calm in its proportion
fire in the orchard and flame at the root.

All the men I've killed weigh
upon my soul until I no longer
know whether I am a Russian
or a Chechen.

Is mood a temple
    to give us
    sanctuary
    against
        the desire
        of our cells
        to return to
            their beginnings
            under a
            new master
            who promises
            that he
            will not
            repeat
        the hesitations,
        compassions
                and
        aesthetic
                com-
        punctions of God
            about
                pleasure
                profit
            and
                progress
            but
                instead
                    will rip up
                    the roots
and give us
the broad
macadam
        of
eternity without fire

and sucaryl
for the syrup
            of the peach.

A WANDERING IN PROSE: FOR HEMINGWAY,
SUMMER 1956

Why do you still put on that face
powder which smells like Paris when
I was kicking Seconal and used to
get up at four in the morning and
walk the streets into the long wait
for dawn (like an exhausted husband
pacing the room where you wait for
the hospital to inform you of wife
and birth) visions of my death
already in the nauseas off my tense
frightened liver—such a poor death,
wet with timidity, ordure and the
muck of a Paris dawn, the city more
beautiful than it had ever been, warm
in June and me at five in an Algerian
bar watching the workers take a
swallow of wine for breakfast, the
city gentle in its light even to me
and I sicker than I've ever been,
weak with loathing at all I had not done,
and all I was learning of all I would
now never do, and I would come back
after combing the vistas of the Seine
for glints of light to bank in the
corroded vaults of my ambitious and
yellow jaundiced soul and there back

in bed, nada, you lying in bed in hate
of me, the waves of unspoken flesh
radiating detestation into me because
I have been brave a little but not nearly
brave enough for you, greedy bitch,
Spanish lady, with your murderous
Indian blood and your crazy purity
hung on courage in men as if it were
your queen's own royal balls, and I
would lie down next to you, that smell
of unguent and face powder bleak and
chic as if the life of your skin depended
now not on the life my hands could give
in a pass upon your cheek, but upon the
arts of the corporation mixing your
elixirs in hundred gallon vats by
temperatures calibrated to the thermostat,
bleak and chic like the Hotel Palais
Royale ("my home away from home" we had
seen written by Capote in his cuneiform
script when the guest book was passed
to me for the equivocal cachet of my
signature so dim in its fashion that
year) and I took up the pen thinking
of the buff-colored damp of our indif-
ferent room where we slept in misery
wondering if we had lost the loots of
anticipation we had commanded once so
fierce in one-another—or was it only
me? for that is the thought of a lover
when his death comes over him in that

scent of the creams you rubbed on your
face while I slept the half-sleep of
the addict kicking the authority of
his poison—how bitter and clean was
the taste of the Seconal. And now the scent
of that cream came over me again as you kissed
me here at this instant, wearing it
again, knowing I detest it because again
it drives the secret of my poor augure
for eternity into those caverns of my
nose which lead back among the stalactites
of the nostril to the dream and one's
nightly dialogue with the fine verdicts
of the city asleep, and all souls on the
prowl talking to one another in the
dark markets of heaven about the future
of what we are to be if one obeys the
shape we gamblers have given to that
tool of destiny—our character. And the
smell of the corporation is still on
your skin mocking what I have done to
mine.

I
know
a town
with
sighs
of
sea
smiled
the
white
witch

I know
a town
that
sails
the
sun

I know
a town
where
light
is dry
and
boats
come
home
with
silver
in their
hold

where
boats
come
home
with
silver
in their
hold

(do not
grieve
the
death
of
little
fish
They
are
lights
that
seek
the
deep)

I know
a town
with
sighs
of sea

white
with
the
tides
of me

white
as the
spine
of the
sea.

finis

# Introduction to
## *Deaths for the Ladies*
## *(and other disasters)*

*Deaths for the Ladies* was written through a period of fifteen months, a time when my life was going through many changes, including a short stretch in the prison ward of Bellevue, the abrupt dissolution of one marriage, and the beginning of another. It was also a period in which I wrote very little, and so these poems and short turns of prose were my lonely connection to the one act that gave a sense of self-importance. I was drinking heavily in this period, not explosively as I had at times in the past but steadily—most nights, I went to bed with all the vats loaded, and for the first time my hangovers in the morning were steeped in dread. Before, I had never felt weak without a drink—now I did. I felt heavy, hard on the first steps of middle age, and in need of a drink. So it occurred to me it was finally not altogether impossible that I become an alcoholic. I hated the thought of that. My pride and my idea of myself were subject to slaughter in such a vice.

Well, this preface is not to recount the story of those years and how I may have come out of them; no, we are here to give a crack of light to the little book that follows. I used to wake up in those days, as I have just remarked, with a drear hangover, and the beasts who were ready to root in my entrails were prowling outside. To a man

living on his edge, New York is a jungle, and such mornings were full of taboo. It was often directly important whether the right or left hand was crossed with water first.

One modest reality used to save such hours from dipping too quickly into too early a drink. It was the scraps of paper I would find in my jacket. There were fragments of poems on the scraps, not poems really, little groupings of lines, little crossed communications from some wistful outpost of my mind where, deep in drink the night before, it had seemed condign to record the unrecoverable nuance of a moment, a funny moment, a mean moment, a moment when something I might always have taken for granted was turned for an instant on its head.

Some of those curious little communications that came riding in on the night through an electrolyte of deep booze were fairly good, many were silly, the best were often indecipherable. This would feel close to tragic. Almost always the sensation of writing a good poem (in the dark of early morning) was followed in the daylight by the knowledge I had gone so deep I could not find my eyes. My handwriting had temporarily disintegrated in the passion of putting down a few words. Somebody had obviously been awash in the rapture of the depths.

It was not so very funny. In the absence of a greater faith, a professional keeps himself in shape by remaining true to his professionalism. Amateurs write when they are drunk. For a serious writer to do that is equivalent to a professional football player throwing imaginary passes in traffic when he is bombed, and smashing his body into parked cars on the mistaken impression that he is taking out the linebacker. Such a professional football player will feel like crying in the morning when he discovers his ribs are broken.

I would feel like crying too. My pride, my substance, my capital, was to be found in my clarity of mind or—since my mind is never so very clear—let us say found in the professional cool with which the brain was able to contend with the temptations and opportunities each leap of intuition offered. It was criminal to take these leaps like an amateur, steeped in drink, wasteful, wanton. To be hearing the inspirations of the angel when one is kissing the fumes is a condition so implicit with agony that it took eighteen centuries of Christendom before Kierkegaard could come back alive with the knowledge that such moments not only existed but indeed were the characteristic way modern man found a knowledge of his soul—which is to say he found it by the act of perceiving that he was most certainly losing it.

I would go to work, however, on my scraps of paper. They were all I had for work. I would rewrite them carefully, printing in longhand and ink, and I would spend hours whenever there was time going over these little poems, these sharp dry crisp little instants, some of them no more and hopefully no less possessed of meaning than the little crack or clatter of an autumn leaf underfoot. Something of the wistfulness in the fall of the wind was in those poems for me. And since I wasn't doing anything else very well in those days, I worked the poems over every chance I had. Sometimes a working day would go by, and I would put a space between two lines or remove a word. Maybe I was mending. As the sense of work grew a little clearer and the hangover receded, there was a happiness working mornings on *Deaths for the Ladies* that I had not felt for years. I loved *Deaths for the Ladies,* not because it was a big book—I knew my gifts as a poet were determined to be small—but because I was in love with its modesty. The modesty of *Deaths for the Ladies* was saving me. Out of the bonfire I seemed to have

made of my life, these few embers were to be saved and set—not every last part of one's memories would have to be consumed. Besides, I wanted to give pleasure. It seemed to me that *Deaths for the Ladies* would give more simple pleasure than any book I had ever written, it was pure, it was modest, it was sad, and it was funny—it was so very modest—how could one not like it? And it even had one innovation to offer poets—so I thought. There was no music or prosody or command or rush of language in the book, no power, not much meter, not at all, much of it was poetry only by the arbitrary insistence of the short line, but *Deaths for the Ladies* was something else, I thought—it was a movie in words. I set it with the greatest care. Every line was placed on the page by me. The spaces were chosen with much deliberation, the repetitions of phrases were like images in a film. The music of the poem as a whole—if it had any—was like the montage of a film. I felt that all of *Deaths for the Ladies* made up one poem, not all that great a poem, never in any way, but still a modest poem about a man loose in our city, for one cannot talk of New York without saying our city, there, majestic, choking in its own passions, New York, the true capital of the Twentieth Century. And *Deaths for the Ladies* was like a small sea breeze running through some of those electronic canyons where a myriad of fine moments were forever dying in the iridescence of foam.

Of course, if you fall in love with a book, you may be certain it will drown, suffocate, or expire all alone on an untended bed. *Deaths for the Ladies* came out in modest edition and sank without a sound. It was only reviewed in three or four places, and the one good review it received (the Sunday *New York Times*) was six months late. Poets, for the most part, resented it. Why should they not? I had dabbled in that life for which

they were willing, if they were good enough, to starve and lose love. They had studied their craft; I had just skipped about in it. They were dedicated to poetry, I was dedicated to climbing out of the hole I had dug for myself, and poetry was offering the first rung. Therefore poets ignored the book, which was a pity, for a good poet might have done something with my little innovation, my movie in words.

But to end on a note less altruistic to the interests of art, let us look at one review. I had secret hopes, I now confess, that *Deaths for the Ladies* would be a vast success at the bar of poetry. The hopes got bounced. Here is the review in *Time*, March 30, 1962:

Ever
see
a drunk
come on
daring
I mean
drunk
like
daring
was a
sloppy
entrechat?
Mr M
comes on
with fourbucks
of poems
about sex
not love
that run
down
like this
only
not
lined up
neat.
Having less

than
fourbucks
fun
a reader
counted
the words
and concluded
Mr M
is making up
for his
first book
which had
too many.
You didn't
score
this
time
M
a
n

But hell you know that.

    In a fury of incalculable pains, a poem was written in reply, sent to *Time* magazine's

column of letters, and printed there.

Poem to the Book Review at *Time*

You will keep hiring
        picadors from the back row
        and pic the bull back
        far back along his spine
You will pass wine
        poisoned on the vine
You will saw the horns off
        and murmur
The bulls are
        ah, the bulls are not
        what once they were

Before the corrida is over
        there will be Russians in the plaza
Swine some of you will say
what did we wrong?
And go forth to kiss the conquerer.

Now, on the comfortable flank of this reminiscence, I think I may have been fortunate to get so paltry a reception on *Deaths for the Ladies*. For if I had been treated well, I might have kept floating on a still little pond and drowned my sorrow for myself in endless wine and scraps of paper and folios of further poems. Instead, the review in *Time* put iron into my heart again, and rage, and the feeling that the enemy was more alive than ever, and dirtier in the alley, and so one had to mend, and put on the armor, and go to war, go out to war again, and try to hew huge strokes with the only broadsword God ever gave any good writer—a glimpse of something like Almighty prose.

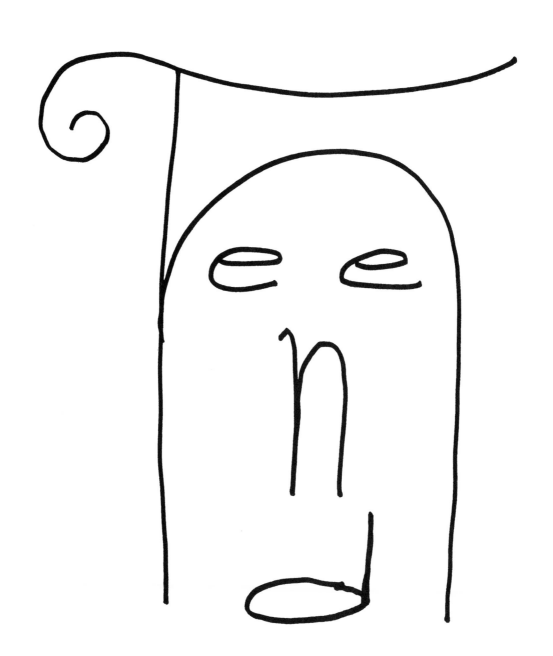

# Acknowledgments

I would like to thank David Ebershoff, Dwayne R. Prickett,
Danielle Mailer, J. Michael Lennon,
and Judith McNally for their
careful reading and criticism
of this book.

## ABOUT THE AUTHOR

NORMAN MAILER was born in 1923 and published his first book, *The Naked and the Dead,* in 1948. *The Armies of the Night* won the National Book Award and the Pulitzer Prize in 1969; Mailer received another Pulitzer in 1980 for *The Executioner's Song.* His most recent books, both published by Random House, are *The Spooky Art* and *Why Are We at War?* He lives in Provincetown with his wife, Norris Church Mailer.

ALSO BY NORMAN MAILER

*The Naked and the Dead*
*Barbary Shore*
*The Deer Park*
*Advertisements for Myself*
*Deaths for the Ladies (and other disasters)*
*The Presidential Papers*
*An American Dream*
*Cannibals and Christians*
*Why Are We in Vietnam?*
*The Deer Park—A Play*
*The Armies of the Night*
*Miami and the Siege of Chicago*
*Of a Fire on the Moon*
*The Prisoner of Sex*
*Maidstone*
*Existential Errands*
*St. George the Godfather*
*Marilyn*
*The Faith of Graffiti*
*The Fight*
*Genius and Lust*
*The Executioner's Song*
*Of Women and Their Elegance*
*Pieces and Pontifications*
*Ancient Evenings*
*Though Guys Don't Dance*
*Harlot's Ghost*
*Oswald's Tale: An American Mystery*
*Portrait of Picasso as a Young Man*
*The Gospel According to the Son*
*The Time of Our Time*
*The Spooky Art*
*Why Are We at War?*

# Contents

## B. Lingerers, Laggards & Blackguards

## II. MALADIES OF CENTRALISTS

## III. LEVELS OF PROCUREMENT

## IV. The Mediocre

## V. A One Night Stand

## VI. Unhappy Marriage

## VII. A Drunken Marriage

## XV. HEMINGWAY REVISITED

## XVI. THE HARBORS OF THE MOON

A Random House Trade Paperback Original

Preface, drawings, and compilation copyright © 2003 by Norman Mailer

All rights reserved under International and Pan-American Copyright Conventions. Published in the United States
by Random House Trade Paperbacks, an imprint of The Random House Publishing Group, a division of
Random House, Inc., New York, and simultaneously in Canada by Random House of Canada Limited, Toronto.

RANDOM HOUSE TRADE PAPERBACKS and colophon are trademarks of Random House, Inc.

The poems in this work were originally published in *Cannibals and Christians* (New York:
The Dial Press, 1966), copyright © 1965 by Norman Mailer, and in *Deaths for the Ladies (and other disasters)*
(New York: G. P. Putnam's Sons, 1962), copyright © 1962 by Norman Mailer.

Grateful acknowledgment is made to *Time* magazine for permission to reprint excerpts from "Review of 'Deaths for
the Ladies' " from *Time* magazine, March 30, 1962, copyright © 1962 by Time, Inc. Reprinted by permission.

Library of Congress Cataloguing-in-Publication Data
Mailer, Norman.
Modest gifts : poems and drawings / by Norman Mailer.
p.   cm.
ISBN 0-8129-7237-6
I. Title.
PS3525.A4152A6 2003
811'.54—dc22      2003058552

Random House website address: www.atrandom.com

Printed in the United States of America

2 4 6 8 9 7 5 3 1